FERMI

Unforgettable Days Afield

Montana Hunting

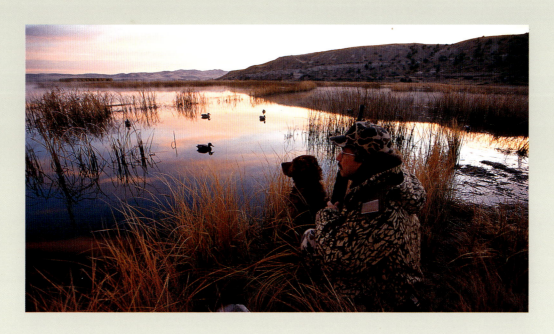

PRECEDING PAGE: *Ready and waiting for the ducks on a calm Montana marsh*/DENVERBRYAN.COM

WORKS & AUTHORS QUOTED

Mark Henckel — THE HUNTER'S GUIDE TO MONTANA

Theodore Roosevelt

José Ortega y Gasset — MEDITATIONS ON HUNTING

John Barsness — THE LIFE OF THE HUNT

Jim Posewitz — BEYOND FAIR CHASE

Charles Fergus — A ROUGH-SHOOTING DOG

E. Donnall Thomas, Jr.— THE RETRIEVER JOURNAL

Charles M. Russell — GOOD MEDICINE

Copyright © 2002 by Riverbend Publishing
All photographs are copyrighted by the photographers.
Published by Riverbend Publishing, Helena, Montana.

Printed in South Korea.

1 2 3 4 5 6 7 8 9 0 SI 07 06 05 04 03 02

Designed by DD Dowden
Edited by Chris Cauble

ISBN 1-931832-16-1

Cataloging-in-Publication data is on file at the Library of Congress.

RIVERBEND PUBLISHING
P.O. Box 5833
Helena, MT 59604
Toll-free 1-866-RVR-BEND (787-2363)
Fax 1-406-449-0330
www.riverbendpublishing.com

RIVERBEND
PUBLISHING

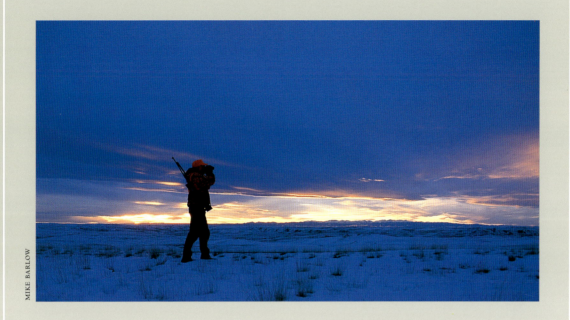

MIKE BARLOW

MONTANA IS HUNTING COUNTRY so rich in opportunity that no hunter could taste all of its pleasures, in all of its locales, in the course of a single season. But it sure would be fun to try.

MARK HENCKEL — *The Hunter's Guide to Montana*

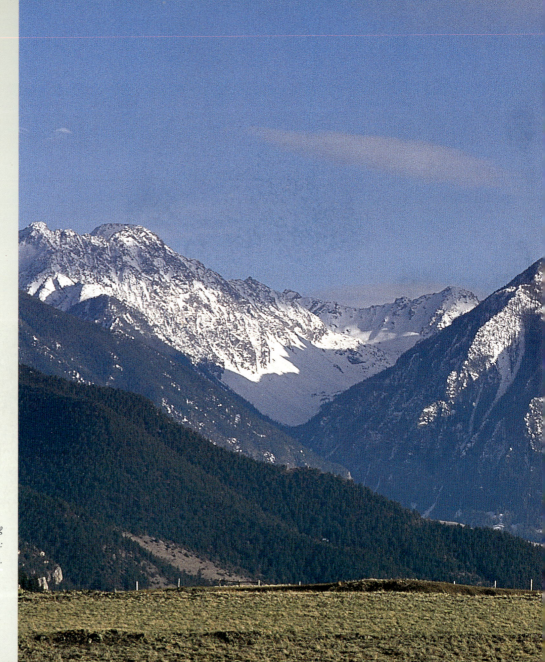

All Montana is big hunting country, and beautiful too: the Absaroka Mountains.

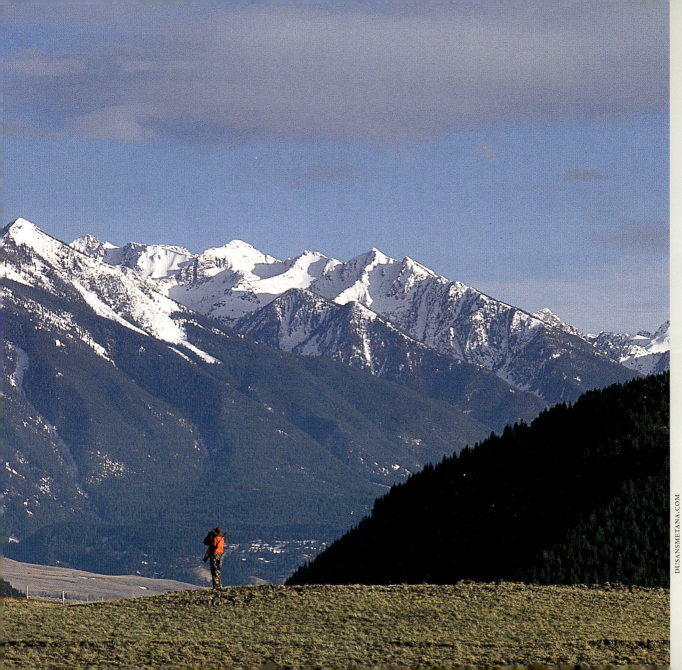

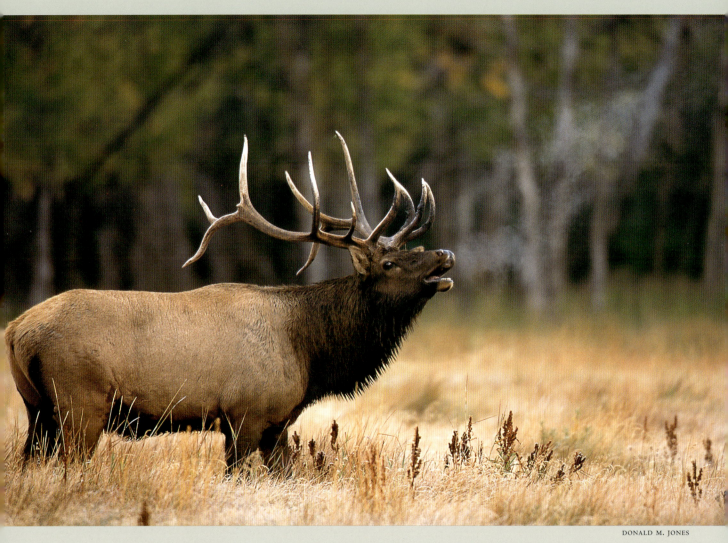

DONALD M. JONES

No other sound quickens a Montana hunter's heart like the roar of a bull elk's bugle.

Hunters on horseback, deep in the Absaroka-Beartooth Wilderness during the early rifle season.

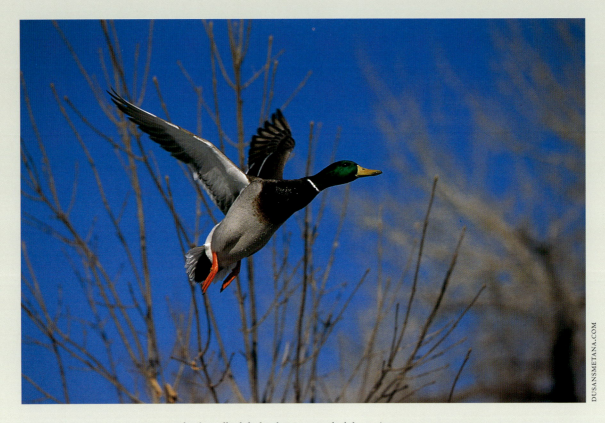

An autumn-bright mallard drake, the Montana duck hunter's most common quarry.

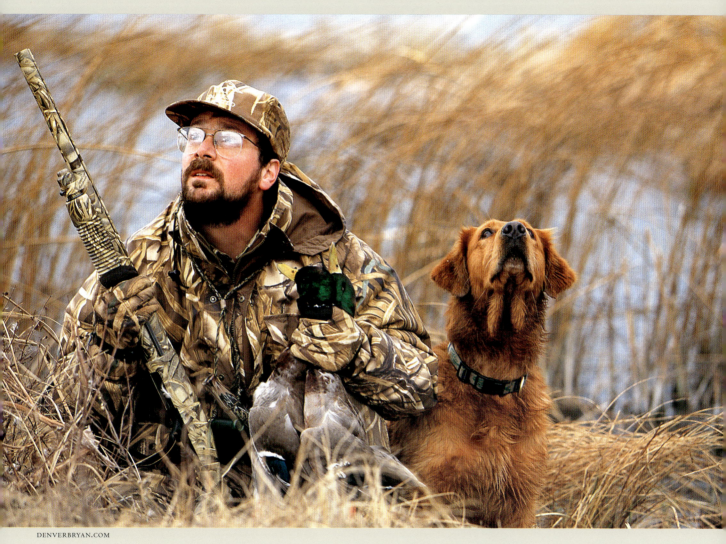

Watching together, hunting together: duck hunter and golden retriever.

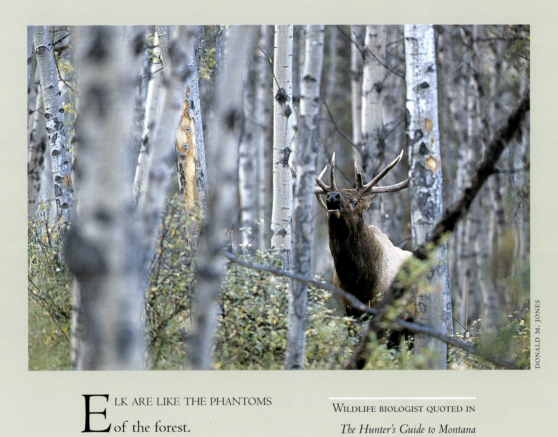

DONALD M. JONES

Elk are like the phantoms of the forest.

Wildlife biologist quoted in
The Hunter's Guide to Montana

H UNTING IN THE WILDERNESS is of all pastimes the most attractive.

THEODORE ROOSEVELT

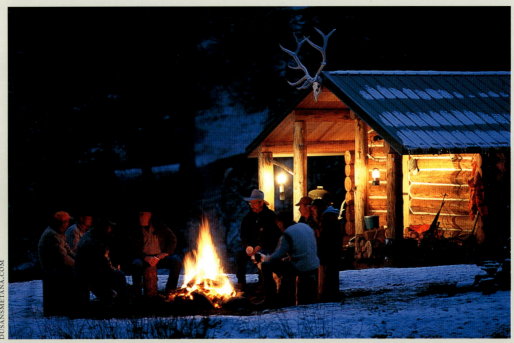

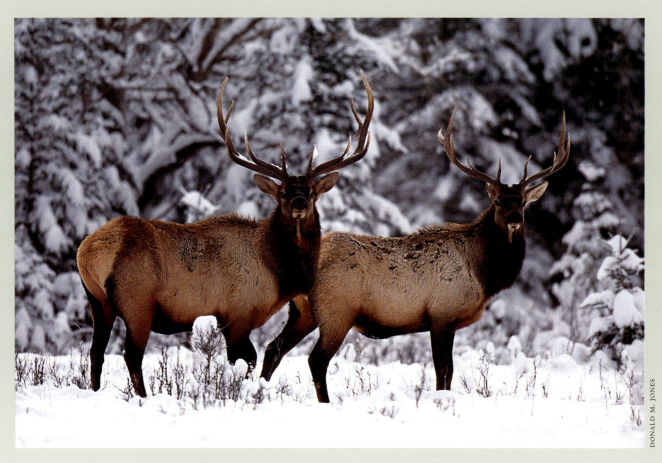

DONALD M. JONES

ABOVE *Typical travel sequence: the biggest bull follows last. So you wait, wait, if you dare wait.*

RIGHT *Packing out quarters and antlers: a November scene often seen, sometimes envied.*

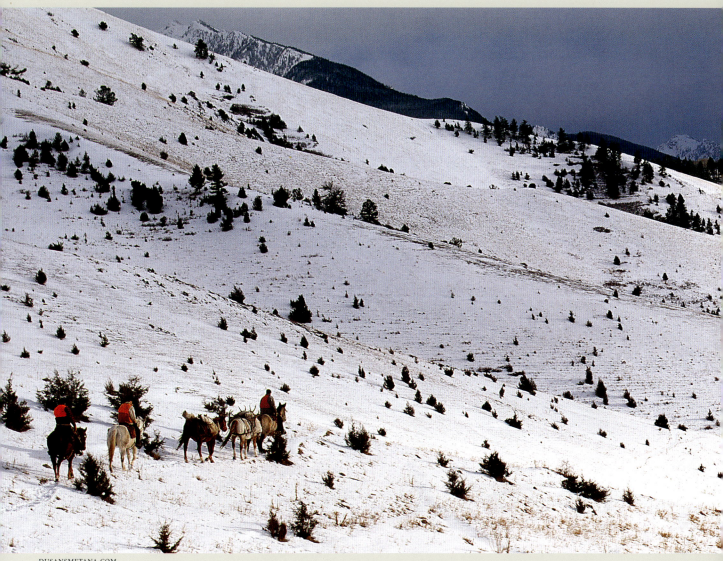

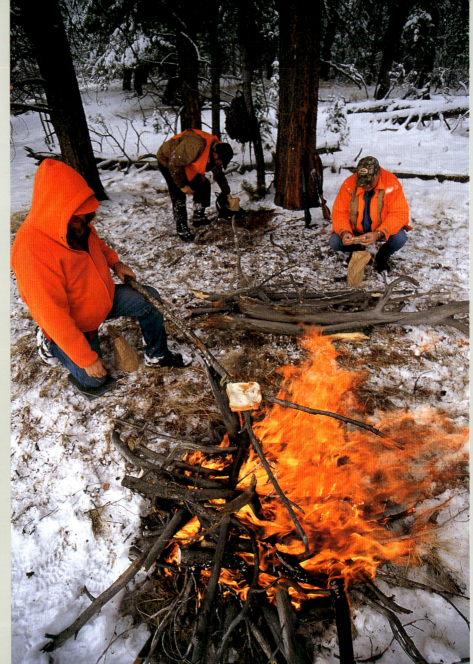

RIGHT *This is sure going to taste good, as soon as I get it thawed out.*

FAR RIGHT *That's a good horse, and the antlers aren't bad either.*

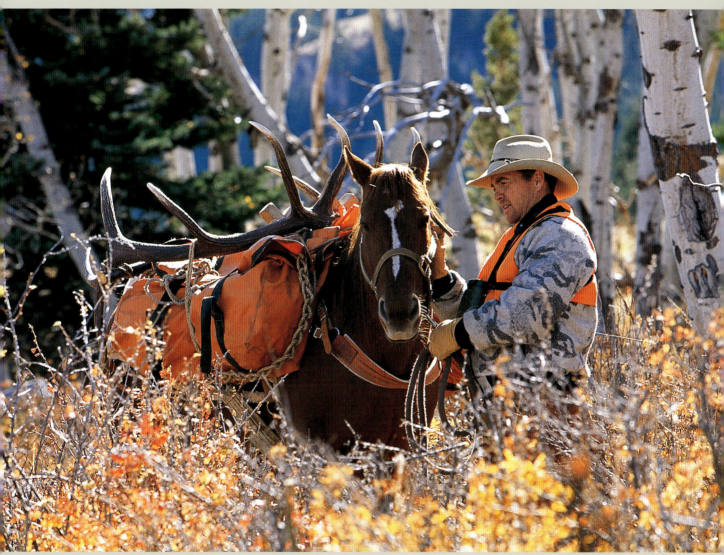

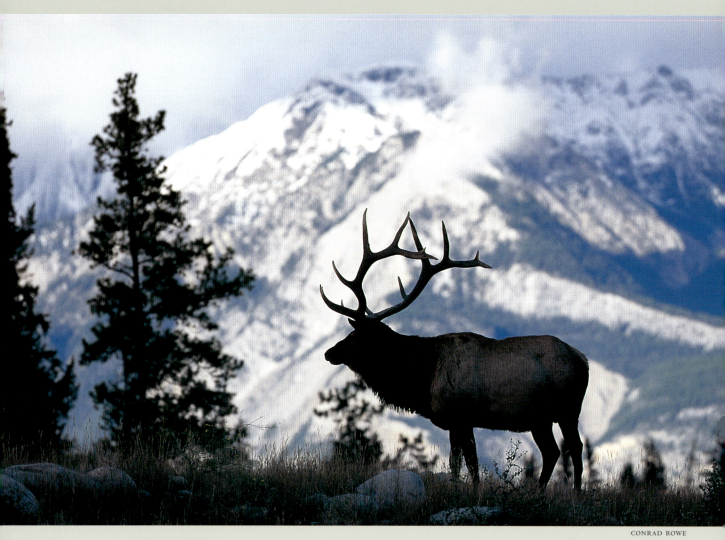

CONRAD ROWE

Dawn is the elk hunter's magic moment, the opening curtain for a day of possibilities.

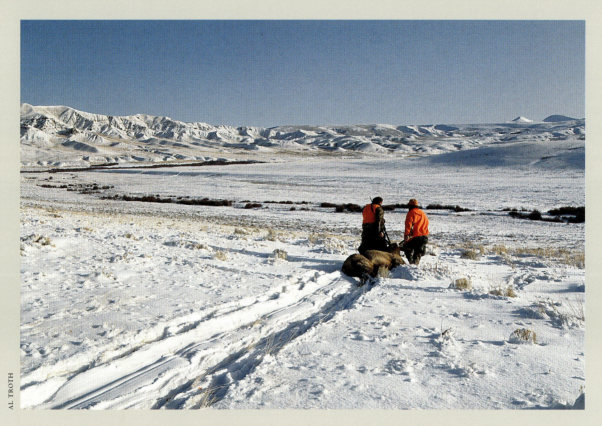

Two make it go, especially downhill on snow, but it still isn't easy. Would we really want it any other way?

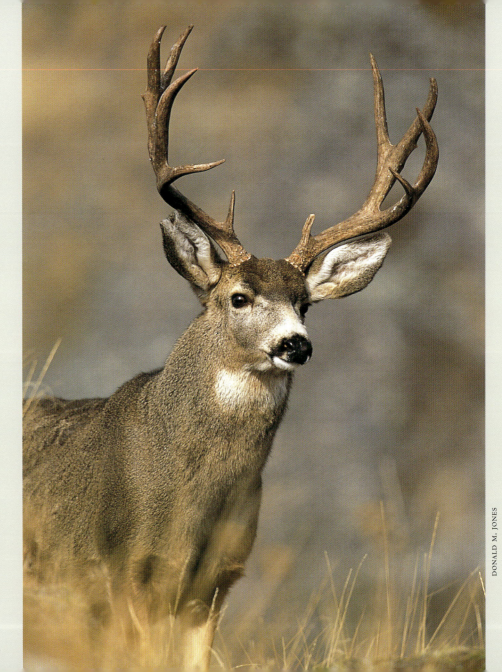

RIGHT *Montanans'
favorite, the mule deer.*

FAR RIGHT *Glassing far
and wide in far
and wide country.*

DONALD M. JONES

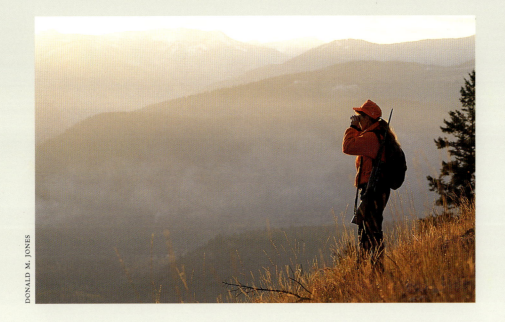

DONALD M. JONES

THE HUNTER KNOWS that he does not
know what is going to happen.

JOSÉ ORTEGA Y GASSET
— *Meditations on Hunting*

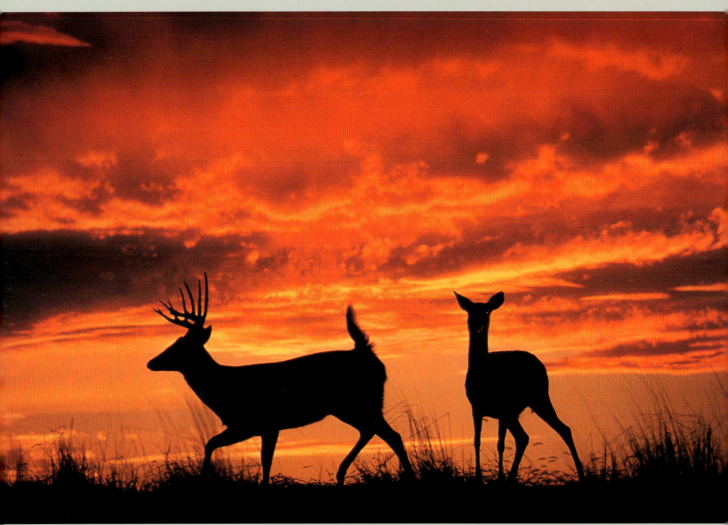

At sunset, you look for whitetail bucks like this, with a bright-eyed doe.

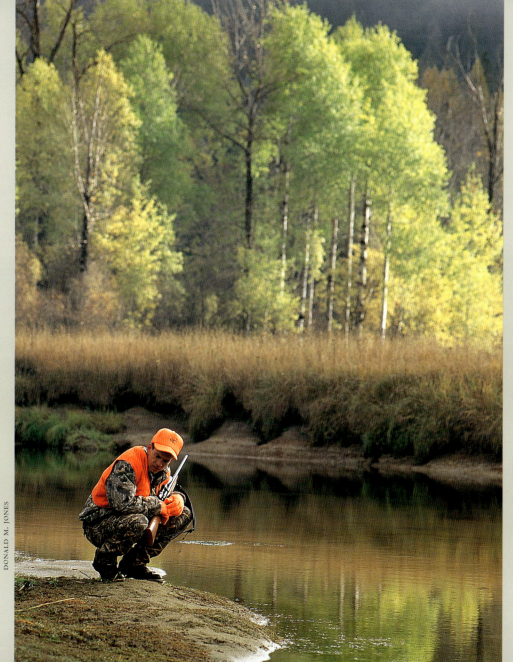

*During the day,
you study its
streamside tracks.*

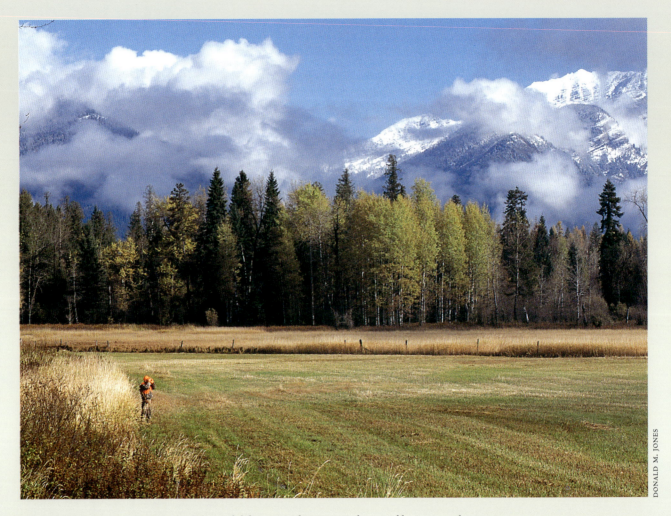

DONALD M. JONES

ABOVE *White-tailed deer prefer edgy country: edges of fields, forests, and mountains.*

RIGHT *And the deer are edgy too, always alert, and always ready to wave goodbye with their white-flag tails.*

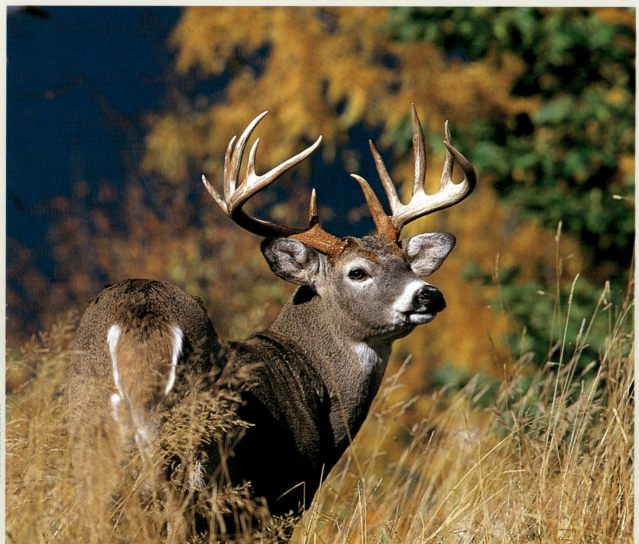

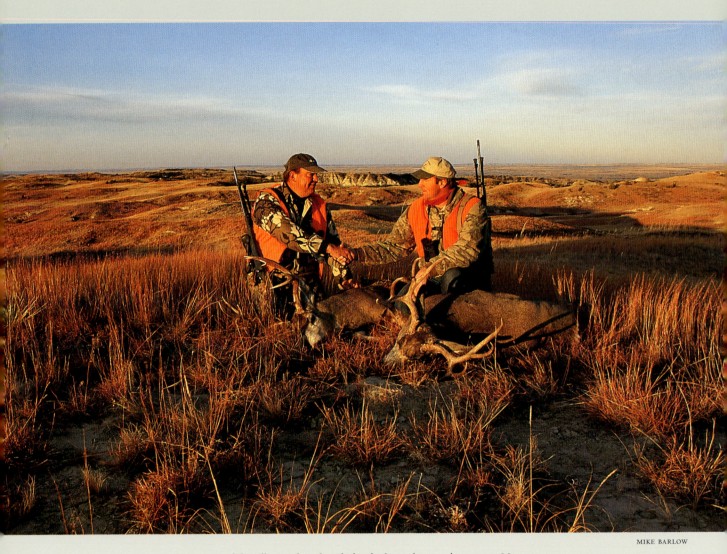

A good day all around, with mule deer bucks on the ground in eastern Montana.

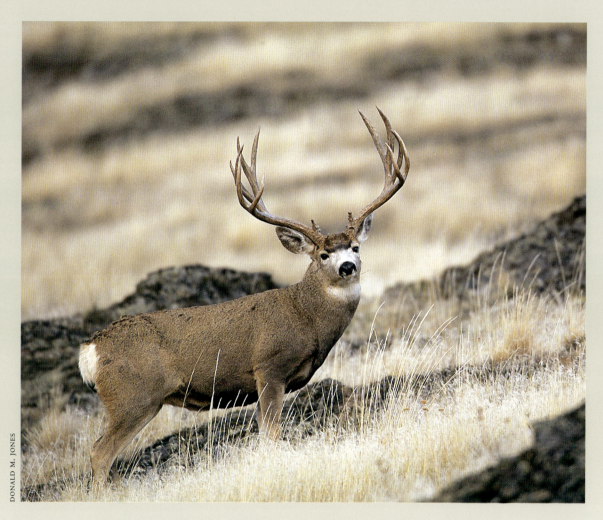

High, wide, and handsome: this mule deer buck and Montana too.

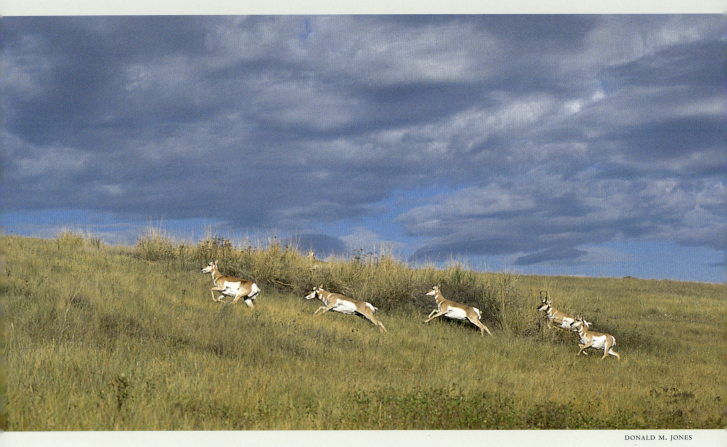

DONALD M. JONES

ABOVE *Pronghorn antelope loafing along in second gear, a buck second from the right.*

RIGHT *When done right, hunting bridges all generations; in this case, antelope hunters on the Montana prairie.*

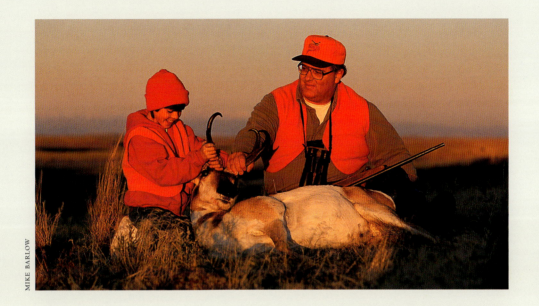

MIKE BARLOW

To FULLY APPRECIATE THAT SPACE of the Western prairies, you must see a
herd of pronghorns gliding across a sea of sagebrush,

bodies so tightly bunched they

appear one animal
 JOHN BARSNESS — *The Life of the Hunt*

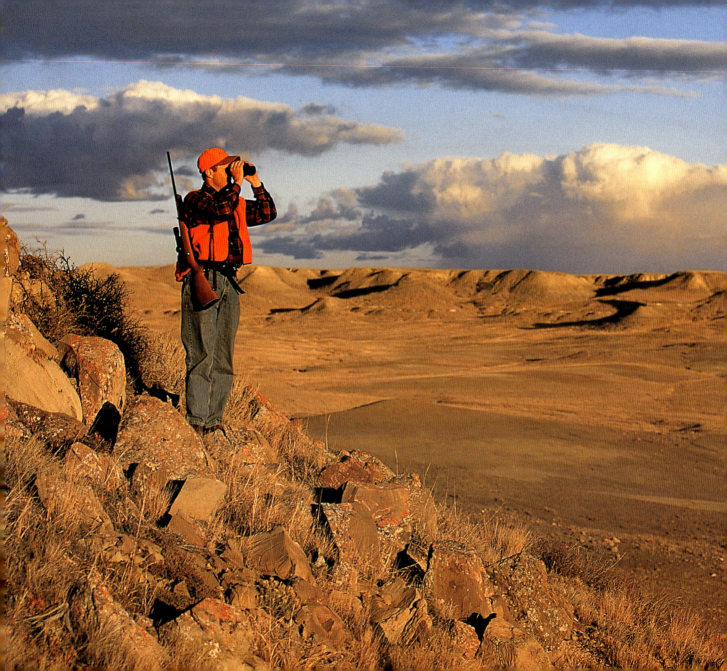

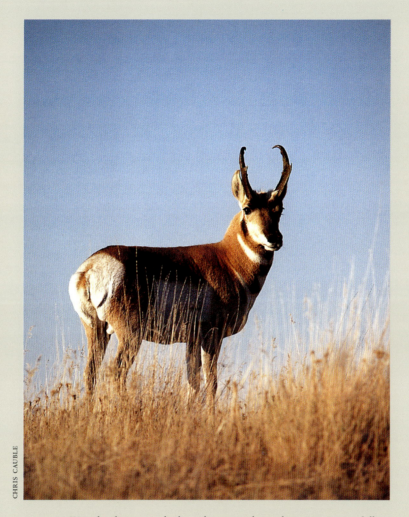

CHRIS CAUBLE

ABOVE *Wise already, a young buck antelope pauses before disappearing over a hill.*

LEFT *This is the pronghorn antelope's house of sky.*

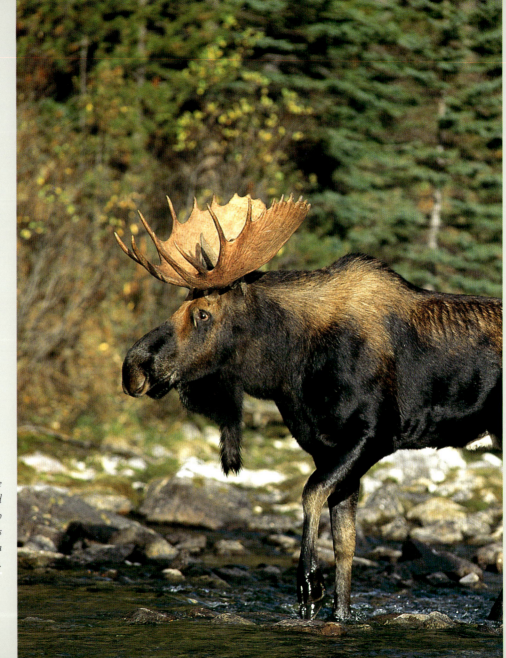

Montana has moose (RIGHT) and bighorn sheep (FAR RIGHT) for hunters lucky enough to draw a special permit.

DONALD M. JONES

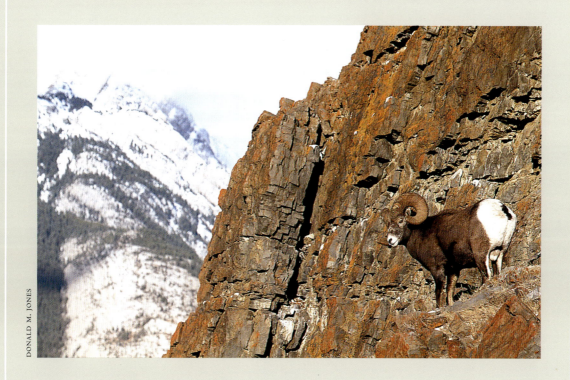

DONALD M. JONES

T HERE WOULD BE NO HUNTING if there were no wild animals.

JIM POSEWITZ
— *Beyond Fair Chase*

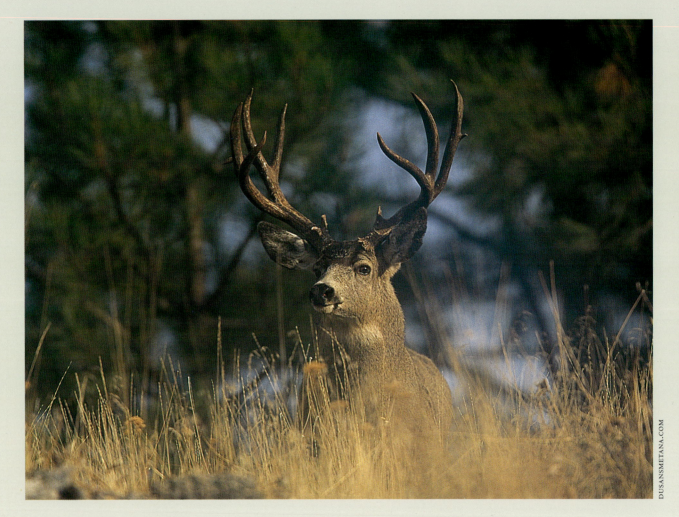

ABOVE *A mule deer buck, ever alert.*

RIGHT *A Montana hunter with a mountain goat permit will get in the best shape of his life, or merely watch from afar.*

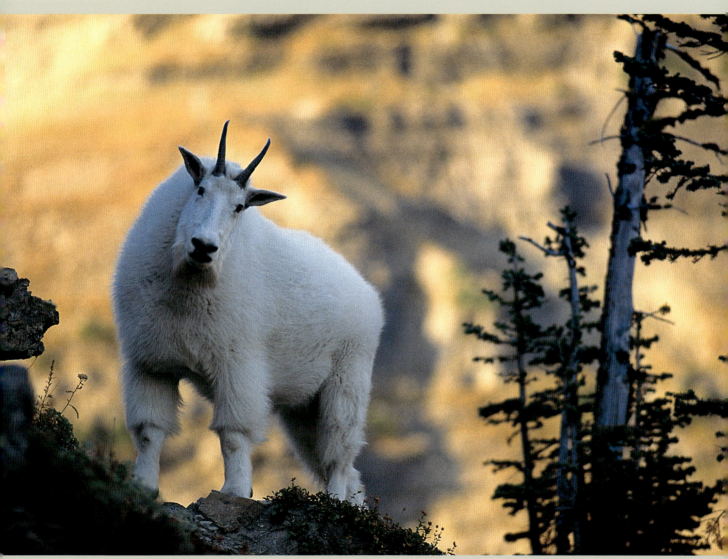

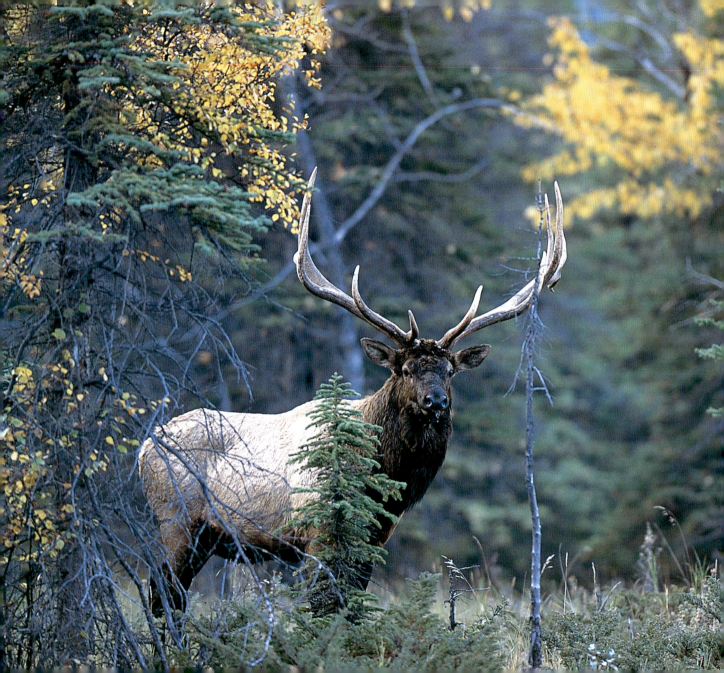

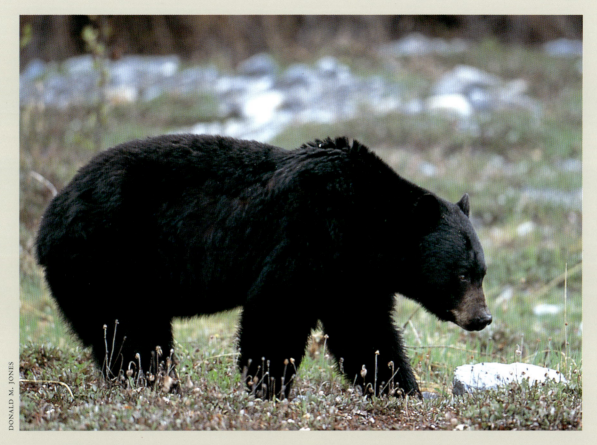

DONALD M. JONES

ABOVE *Spring and fall, black bears lure Montana hunters to the mountains, where hunters need to watch for grizzlies too—and know the difference.*

LEFT *You've been seen, and there's no shot with that little tree in the way. Want to bet the elk spins away without giving you a shot? How do they do that?*

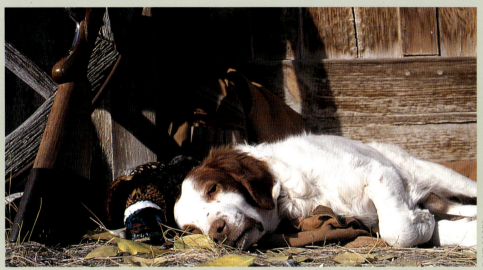

DAVE BOOKS

T O BE OUT ON THE LAND in all weathers, the gun barrels warm in the sun
 or shelved with snow or beaded with rain … to come home fully spent,
empty-handed or bearing food for the table …
this is what it is to hunt.
This is what it is to live.

CHARLES FERGUS — *A Rough-Shooting Dog*

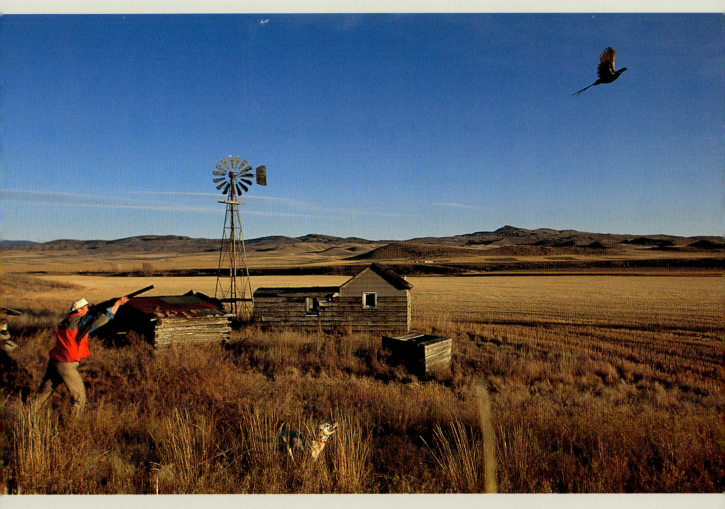

ABOVE *Pheasants—and pheasant hunters—like old, abandoned homesteads with nearby fields of grain and endless, endless Montana skies.*

LEFT *It took a lot of hunting to get this pheasant. This Brittany spaniel deserves a rest.*

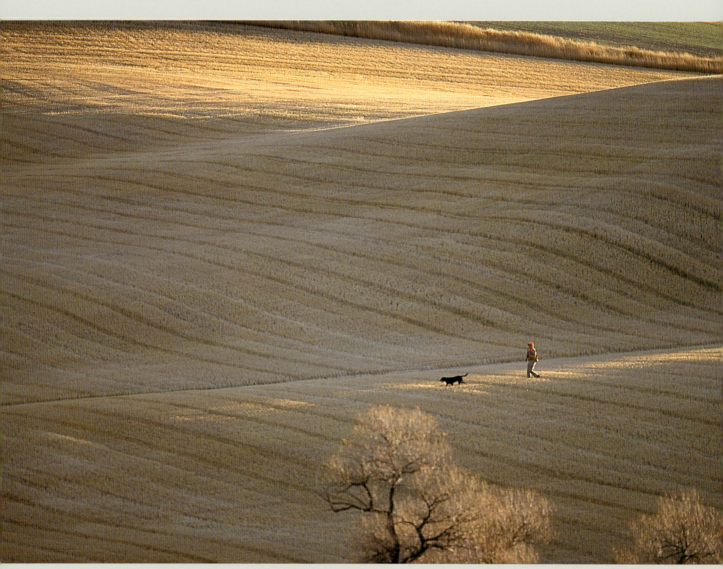

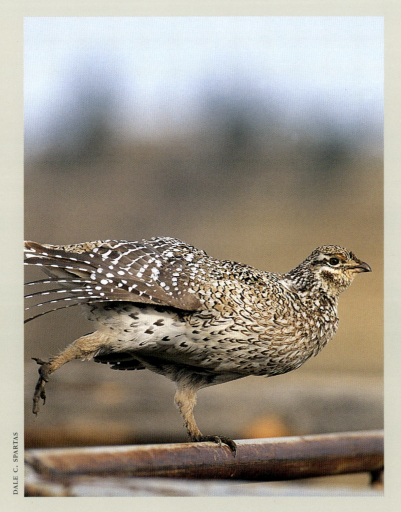

DALE C. SPARTAS

ABOVE *Morning stretching exercises for a sharp-tailed grouse on a ranch gate.*

LEFT *Walking a grain field for sharp-tailed grouse, and maybe a pheasant or two.*

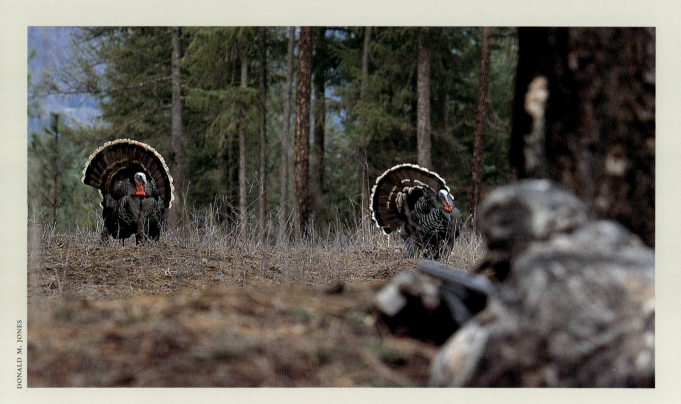

DONALD M. JONES

ABOVE *Even the wiliest of toms can't resist strutting in the spring.*

LEFT *A turkey in hand is always reason to celebrate.*

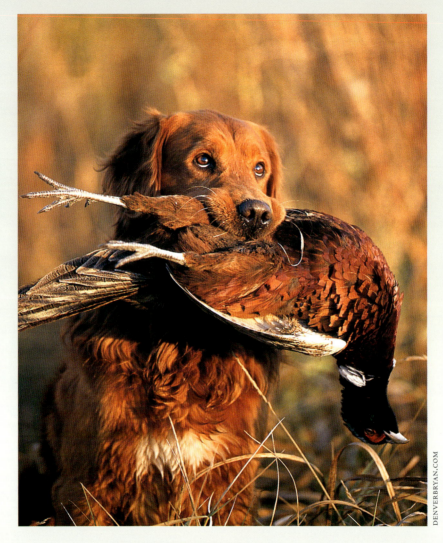

This dog can hunt. A pretty pleased golden retriever.

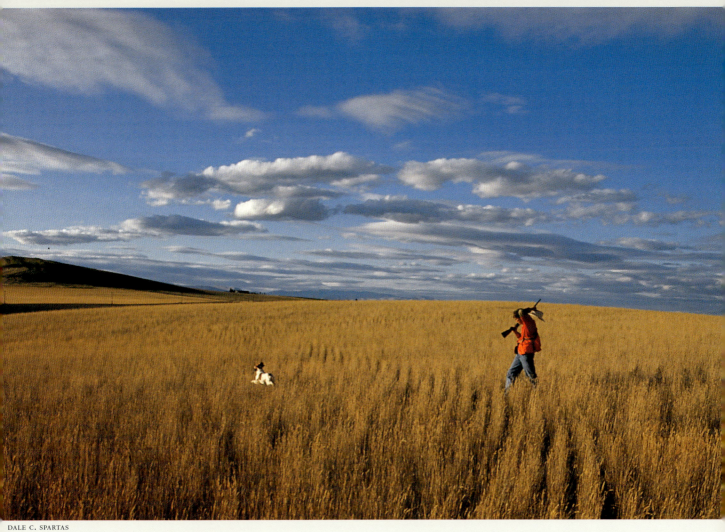

Well, somewhere there's got to be birds. But on a day like this, does it matter?

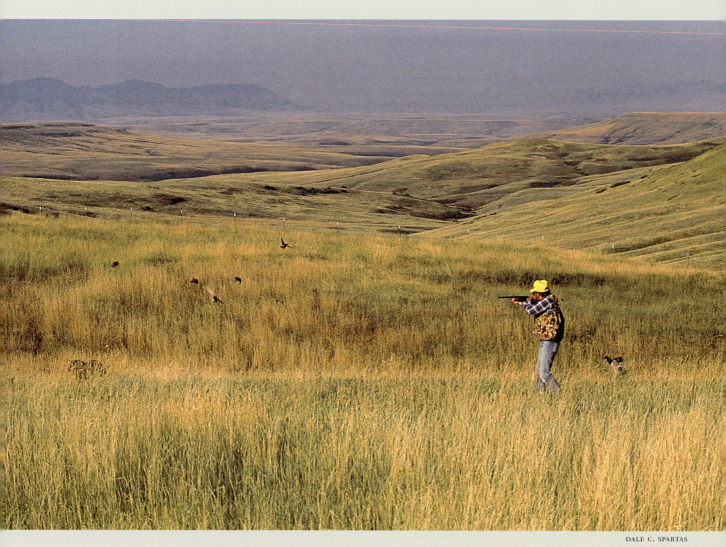

Hungarian partridge burst away in central Montana foothills.

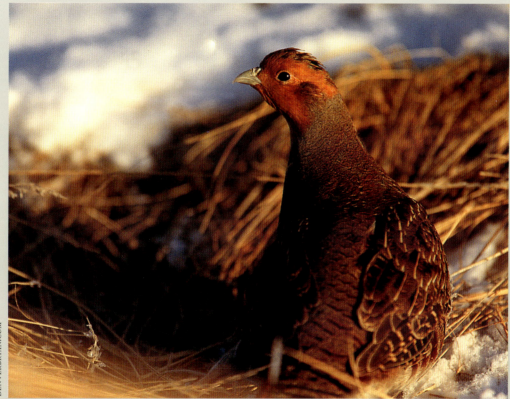

A "Hun."

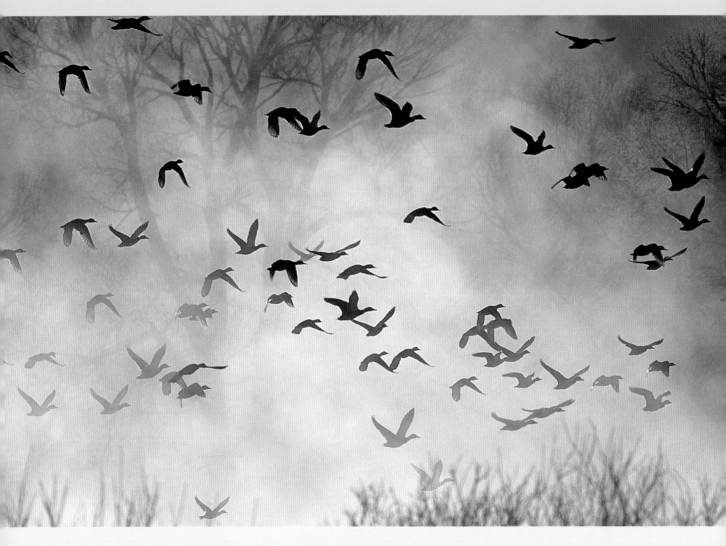

ABOVE *A flock of ducks cleaves through cold morning fog, among the best of Montana days.* RIGHT *Wing feathers on a green-winged teal.*

THE AIR IS SO COLD AND STILL that sounds seems to carry forever, and we can hear a growing swell of feeding chuckles and flight noises sweeping towards us. Then the wings are tearing the air apart

like so much old cloth

and the ducks are there

E. DONNALL THOMAS, JR. — *The Retriever Journal*

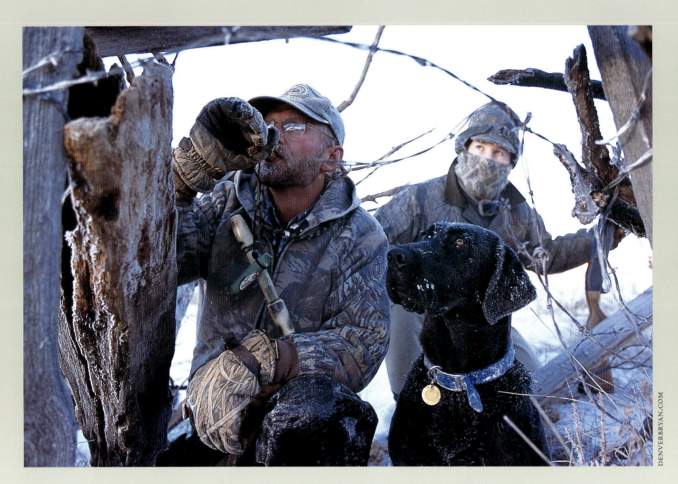

No one feels the cold when the ducks are cautiously circling just overhead.

It's not so cold when you've just managed a double, either.

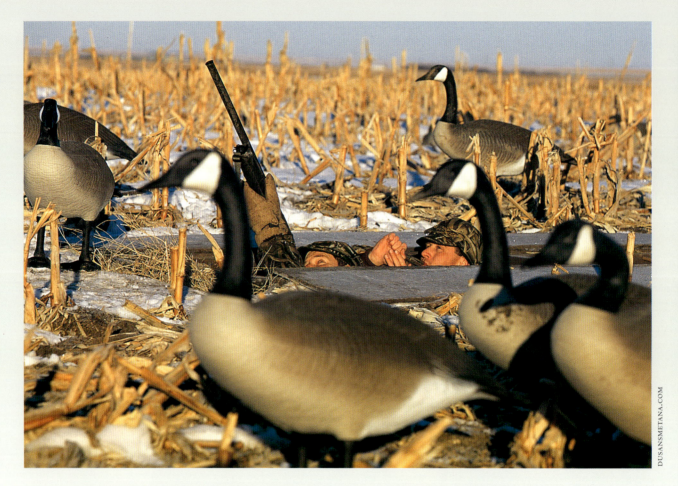

ABOVE *Goose hunting in a field pit, surrounded by decoys and hoping the caller sounds good to the geese.*

RIGHT *Black, white, and blue: snow geese filling the sky at Freezeout Lake.*

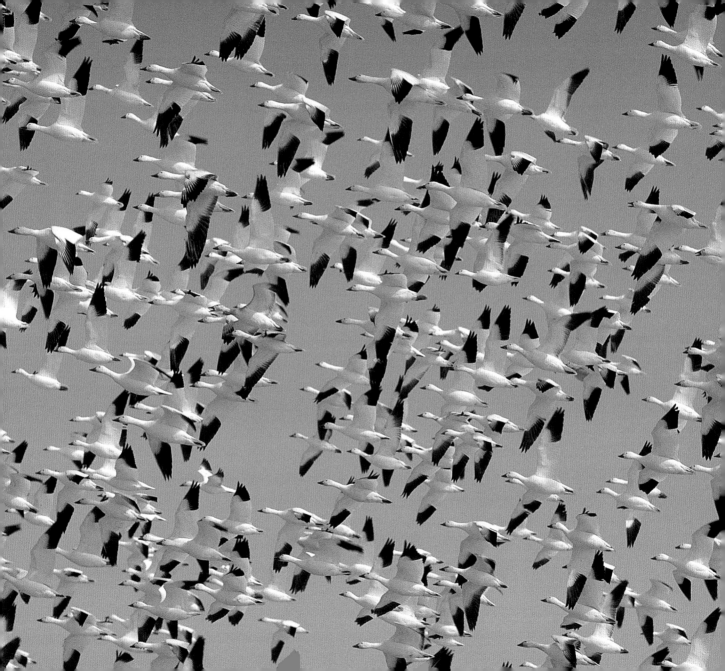

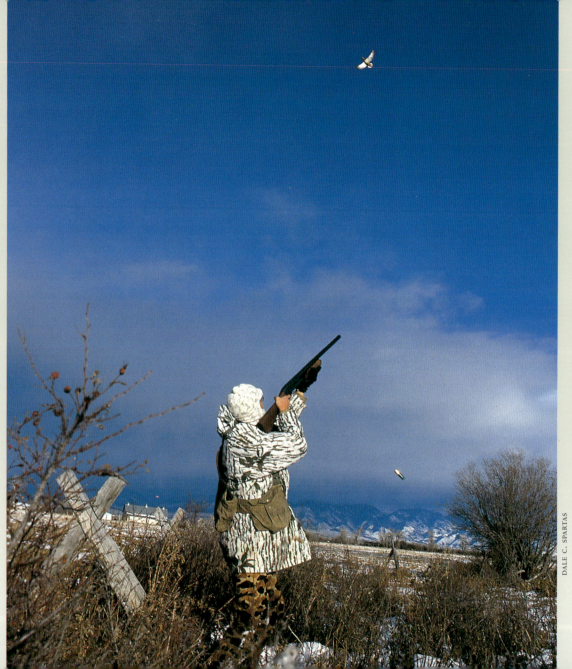

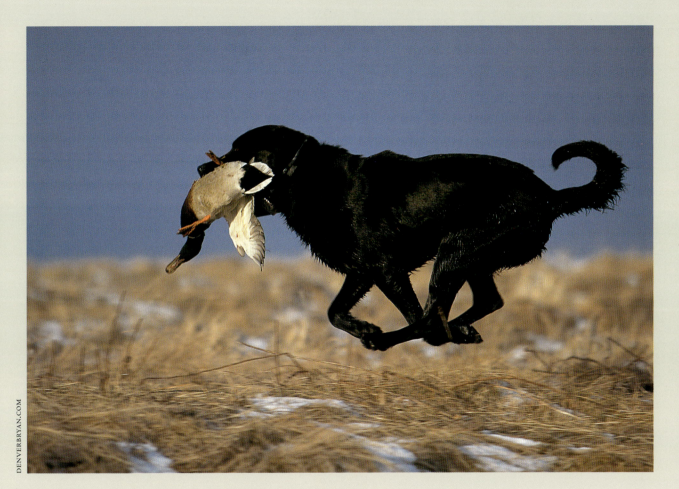

ABOVE *A dog hunting is a happy dog: Labrador retriever in flight with a mallard.*

LEFT *Even if you miss, it's still a thrill.*

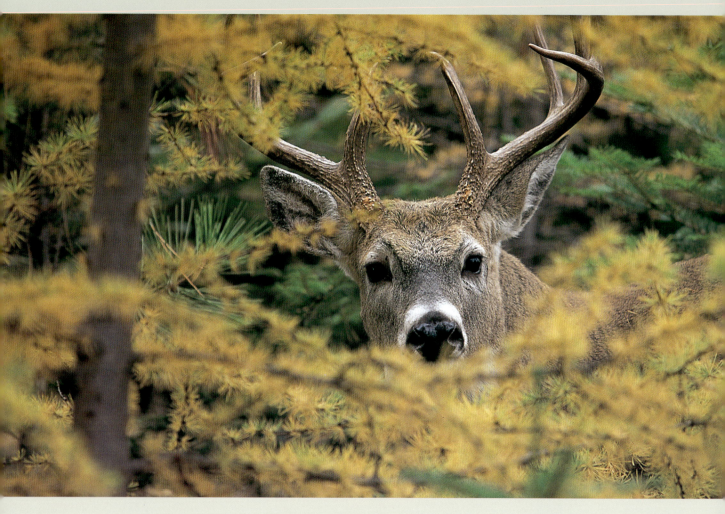

ABOVE *Northwestern Montana whitetail buck, looking good behind autumn-colored larch needles.*

RIGHT *Hunting memories go well with sharpening knives and cleaning rifles. So do a hunter's hopes for tomorrow.*

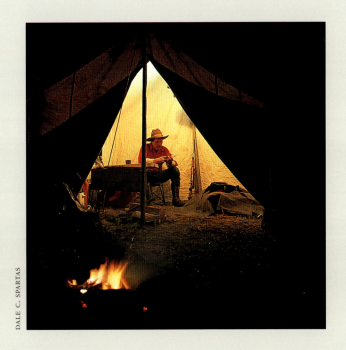

DALE C. SPARTAS

Montana has the hunting country which provides those rich, sensual memories and the wildlife that most hunters, in most other places, can only dream about.

MARK HENCKEL — *The Hunter's Guide to Montana*

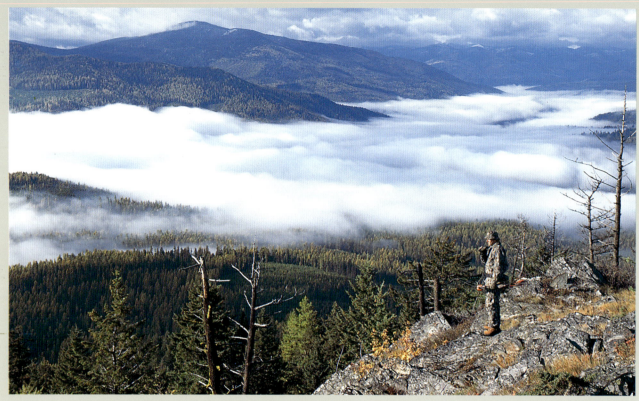

DONALD M. JONES

ABOVE *Bowhunting for elk in country big enough for its own clouds.*

RIGHT *As big as all Montana: a majestic bull elk.*

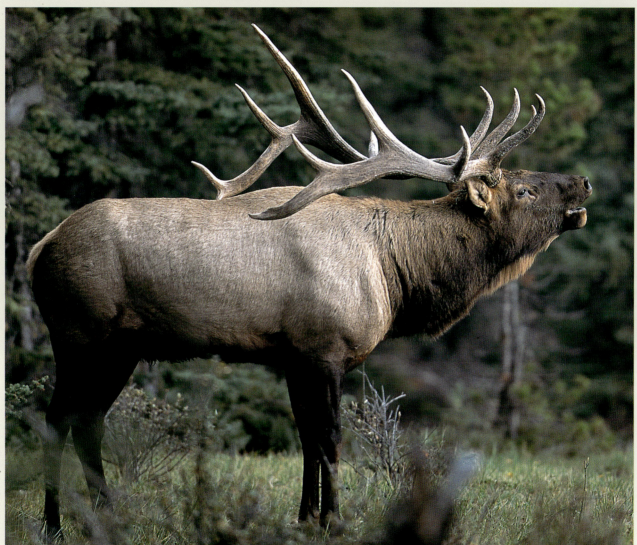

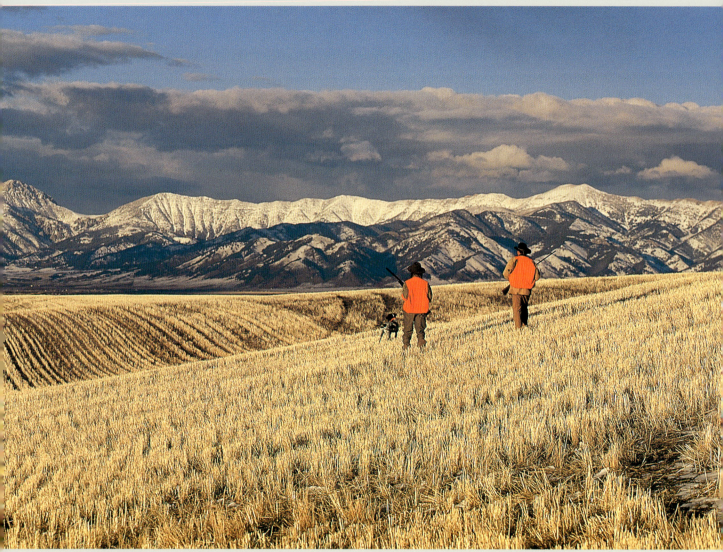

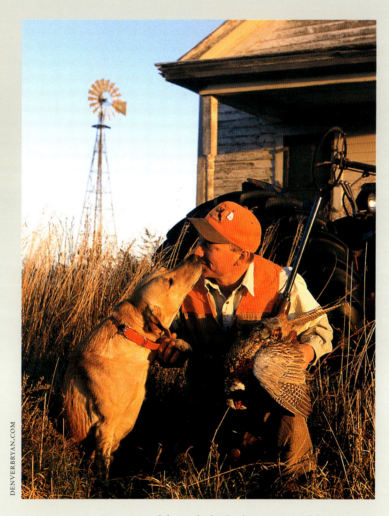

DENVERBRYAN.COM

ABOVE *Yes, yes, you did a good job. Thank you, yes. Good dog.*

LEFT *They say you can't eat the scenery, but it sure seems like there's something nourishing in this scene.*

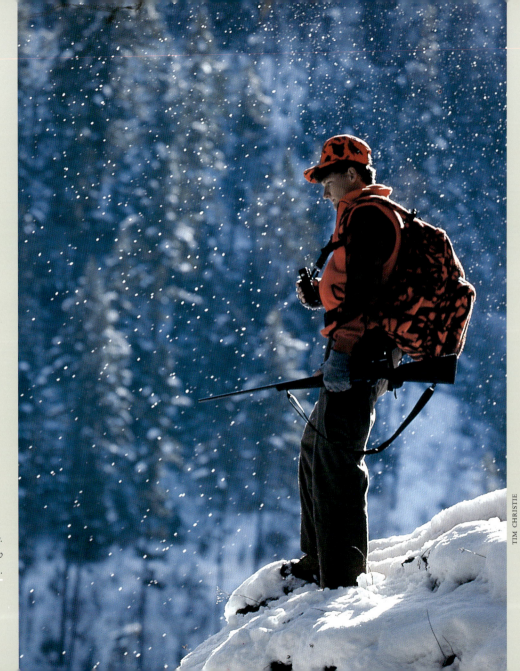

Looking, looking, looking.
It takes a lot of looking to
hunt Montana.

TIM CHRISTIE

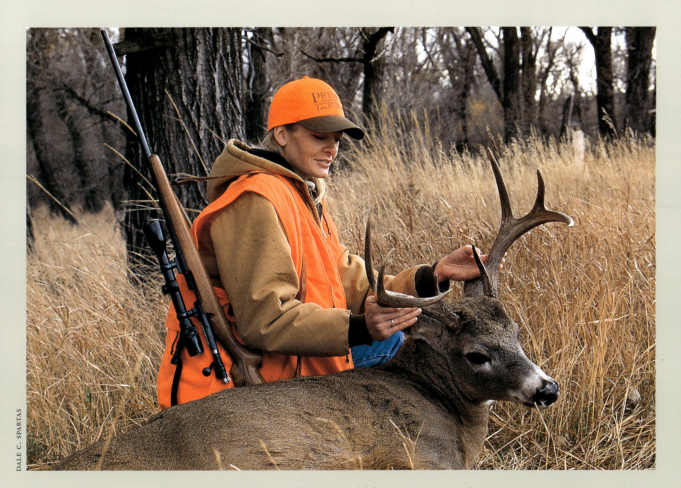

Big cottonwood river bottoms and big white-tailed deer: Montana east of the mountains.

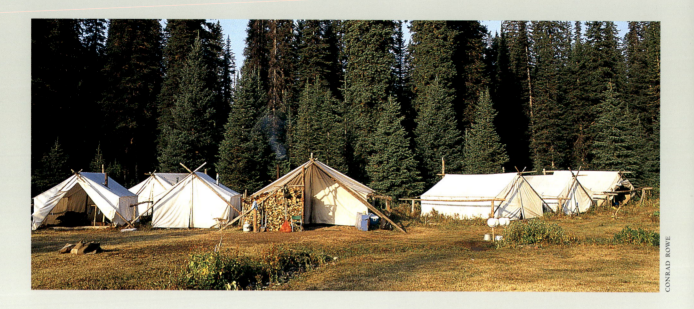

ABOVE *Deluxe backcountry elk camp.*

RIGHT *Low budget, high effort—and successful—backcountry elk camp.*

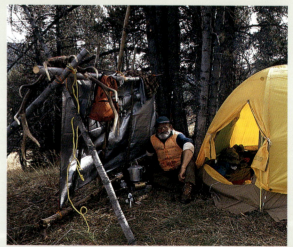

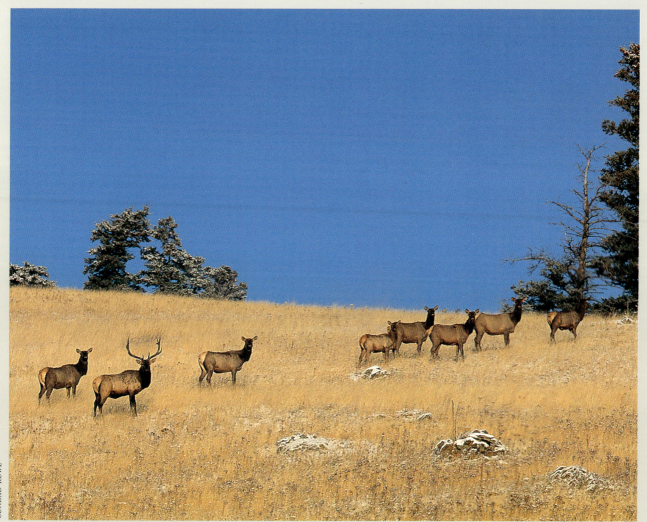

No matter the camp, Montana elk are where you find them.

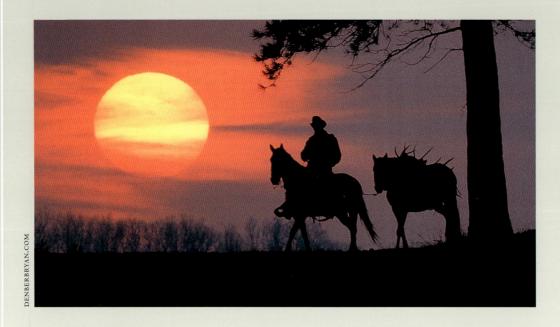

DENBERBRYAN.COM

In October I went hunting with a party of seven on the head of the south fork of the flat head. …we shure got in a wild country and

we had all the meat we wanted….

I dident kill aney thing but I had a good time.

CHARLES M. RUSSELL — *Good Medicine*